Harry's Art

Harry's Art

Harry Nicolas

iUniverse, Inc.
New York Lincoln Shanghai

Harry's Art

iUniverse books may be ordered through booksellers or by contacting:

iUniverse
2021 Pine Lake Road, Suite 100
Lincoln, NE 68512
www.iuniverse.com
1-800-Authors (1-800-288-4677)

Because of the dynamic nature of the Internet, any Web addresses or links contained in this book may have changed since publication and may no longer be valid.

The views expressed in this work are solely those of the author and do not necessarily reflect the views of the publisher, and the publisher hereby disclaims any responsibility for them.

ISBN: 978-0-595-44113-6 (pbk)
ISBN: 978-0-595-88437-7 (ebk)

Printed in the United States of America

Contents

Introduction

Ever since childhood, art has been a passion of mine. I've also always had a great interest in museum art displays. But someday, I thought, I will bring a unique style to the field—my own artistic vision. The ideas just kept coming to me, day and night, so I was compelled to express them in this book. For example, by simply looking at the sky and the natural world that surrounds us, one can imagine great art. Now let me introduce *Harry's Art*, a book in which you will find some great sketches as you go deeper and deeper into its pages. I can name a few on display here: *Citadel, Synchronize Stretch, Negro, The Chair, Soccer Explosion, The Human Bridge, The Verdict, We Are One, Let's Dance, The ICU Code, The Maestro Plays,* and more. I invite you, the reader, to enjoy this unique book. What makes this book so special is that its contents magically transcend the comprehension of the various themes explored in this book. Such themes have never been broached in such a way.

Harry's
Art

My Clone

This is the mystery man, the Renaissance man. Scientific cloning may be controversial. After numerous experiments, documentation, cell research, and the vast wealth being spent, cloning could have a positive or negative impact. It depends on who you clone.

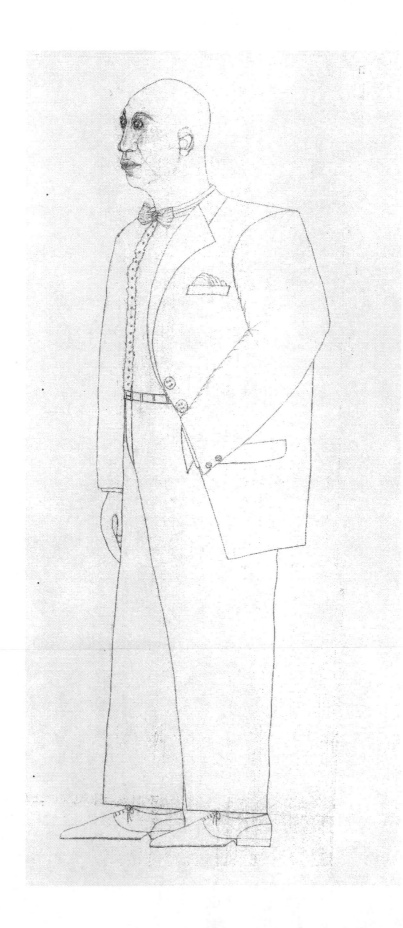

Citadel

Here's the eighth wonder of the world. As visitors climb up to the top of the hill, they can see an unbelievable masterpiece located at Milot on the North Country side of Cap Haitian, my beloved homeland. It's a colossal fortress on the mountain peak built by Henry Christophe. You notice that you're close to the sky and say, "Oh, my God, I feel so powerful standing up here." The structure was built with the blood and sweat of more than two hundred thousand slaves and animals. Back then, the only mode of transportation was a donkey that carried you up a snake path from the bottom of the mountain. It was too tiring for humans to climb, even making many stops.

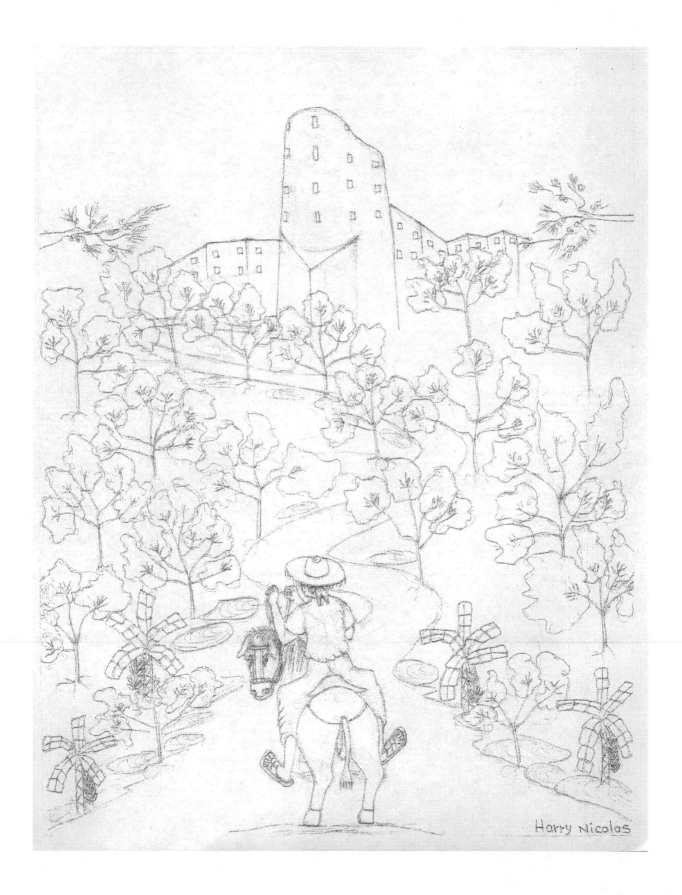

Harry Nicolas

Negro

The idea of slavery is repellent and not a good example for anyone to follow. We were born to be free. This is a celebration of freedom. It's great to be free, but this is bittersweet. This sketch depicts the first black Haitian breaking the chains of agony, blowing on the conch shell while raising the powerful machete under the burning sun. Let freedom reign.

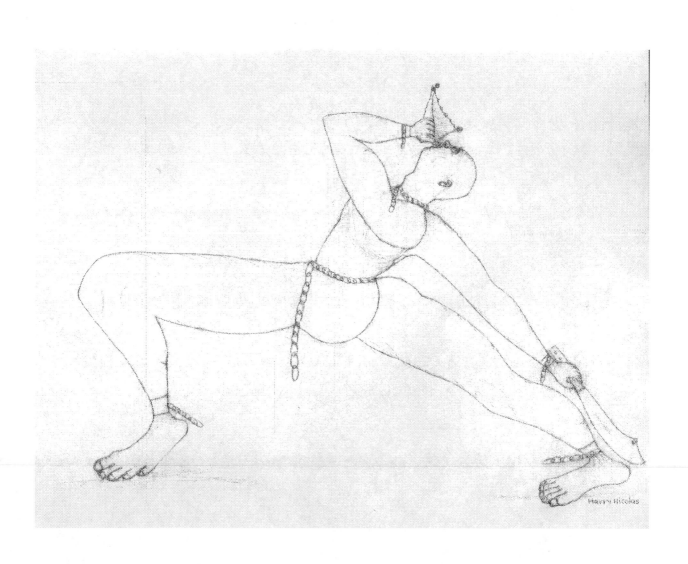

The Private Bathroom

This scene represents the masculine execution of "number one" freely. Sometimes it is a huge relief when this takes place. Often one barely has a chance to get to a facility quick enough when one has to go.

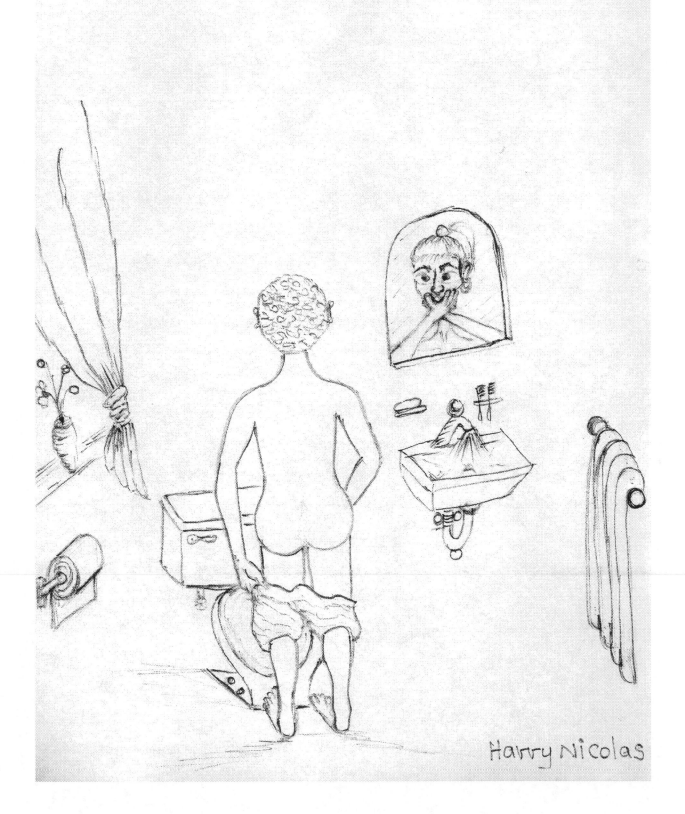

Harry Nicolas

Synchronize Stretch

How beautiful it is to relax your body. It's good for your health to melt stress away. By looking at this master-piece from a certain angle I show the magnificence of the human body while exercising. The human form is a work of art created by God and a precious treasure.

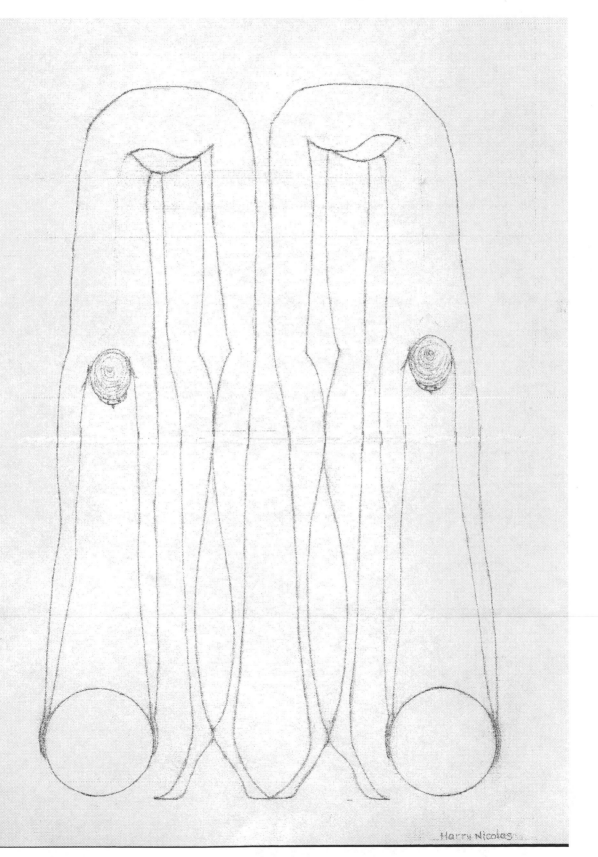

Harry Nicolas

A Devoted Teacher

Not everyone can teach. It requires dedication and love. Depicted here is a teacher who has been teaching for over fifty years. She is a hard worker and is well experienced. In this portrait you can look at her in a typical classroom session. There are not many teachers like her who deserve such tribute.

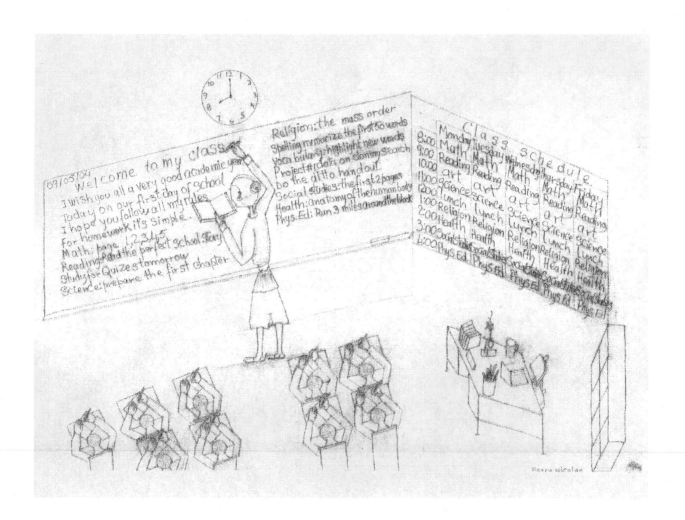

The Verdict

Here, the judge was about to read the verdict. The perpetrator made his way up to the bench and strangled the honorable judge.

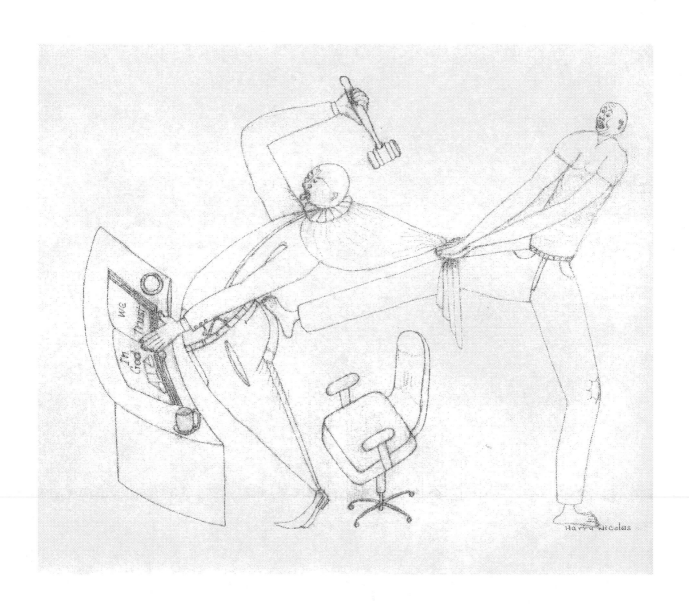

Dive into Reading

For the passionate reader, this is a glimpse of paradise. This is tender loving care for books. I exhibit this gray, bald man at the top of the Millennium Library ladder. He sweats as a stream of light illuminates him. He is immersed in his reading.

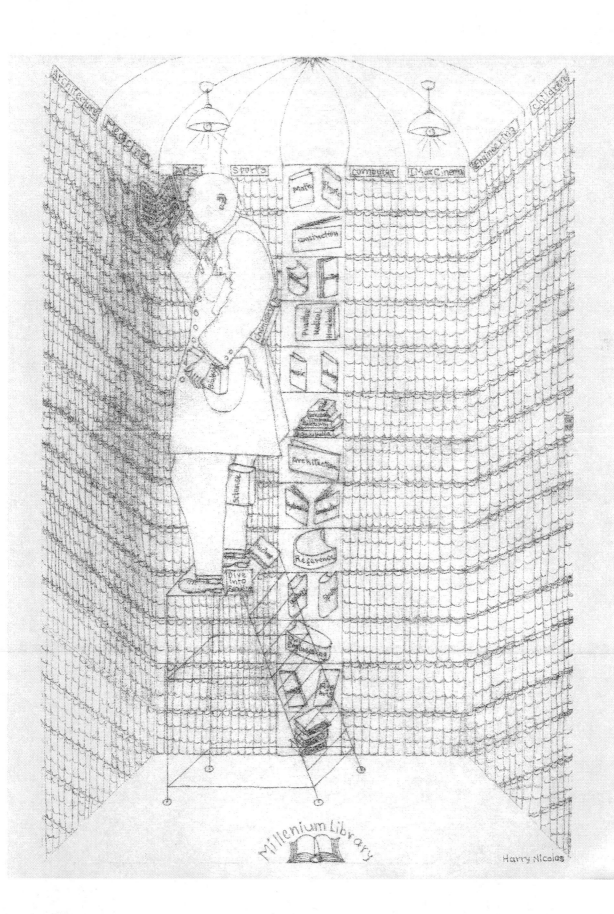

Let's Dance

This is a showdown between Mr. Stick and the ballerina. They dance to their favorite piece, the *Nutcracker Suite*.

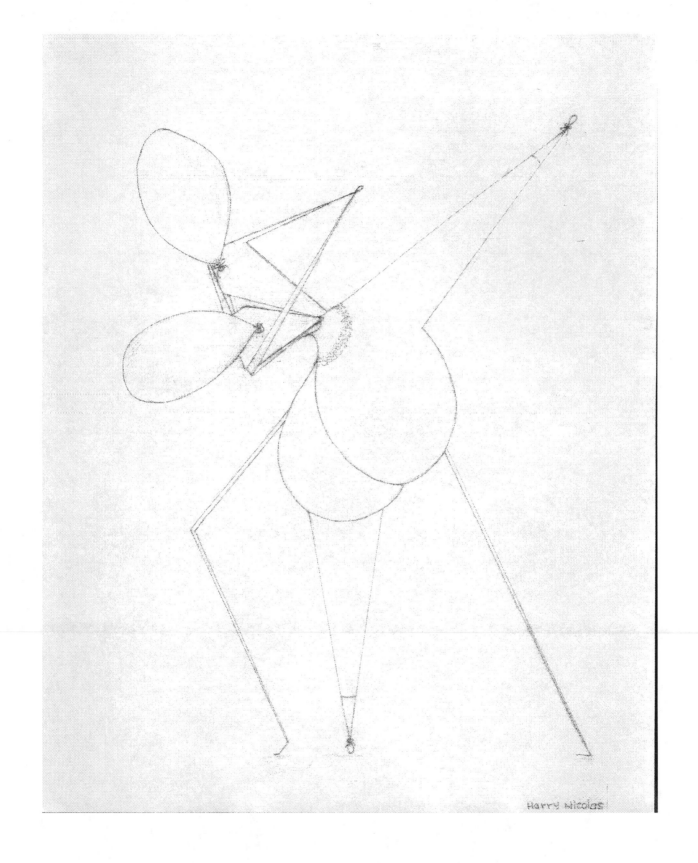

Harry Nicolas

Cheater

Here, two buddies decide to have fun, but their card game is turned around. At the last moment, one of the players pulls a hidden card to win the game. Once in a while, even best friends will do the meanest things just for sport.

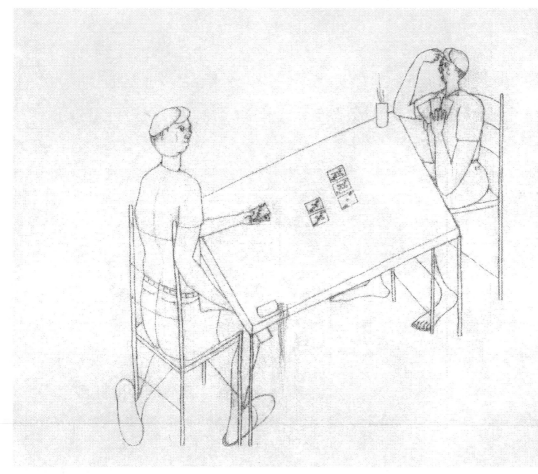

A Father's Joy

Here you see a proud father from the moon admiring this precious bundle of joy. There's nothing safer than a father's love and care?

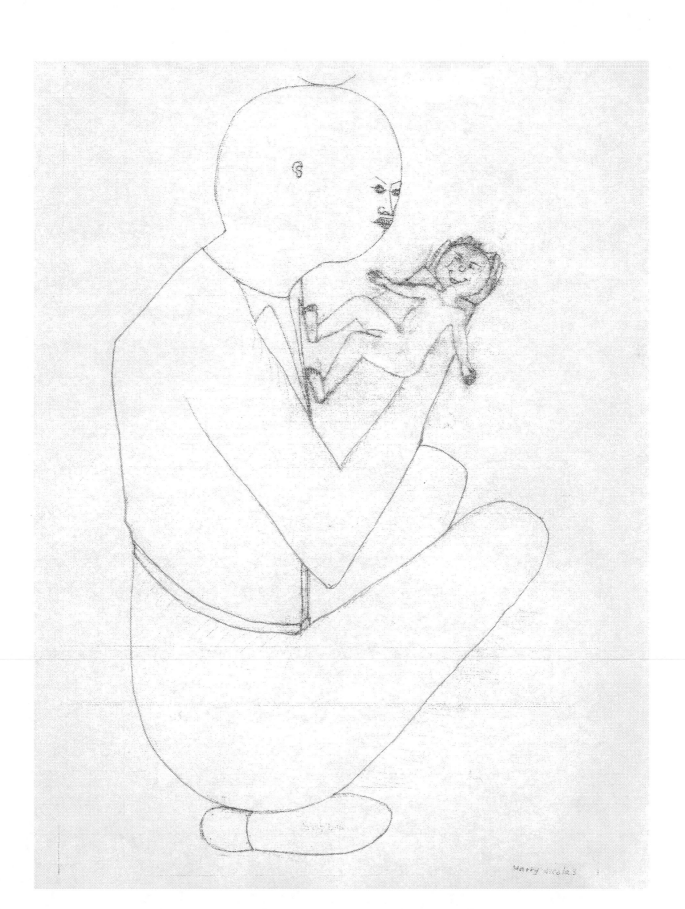

Harry Nicolas

The Big Picture

Sometimes tragic events happen when you least expect them tot. These unexpected tragedies have changed many people's lives and have forced them to start their lives all over again.

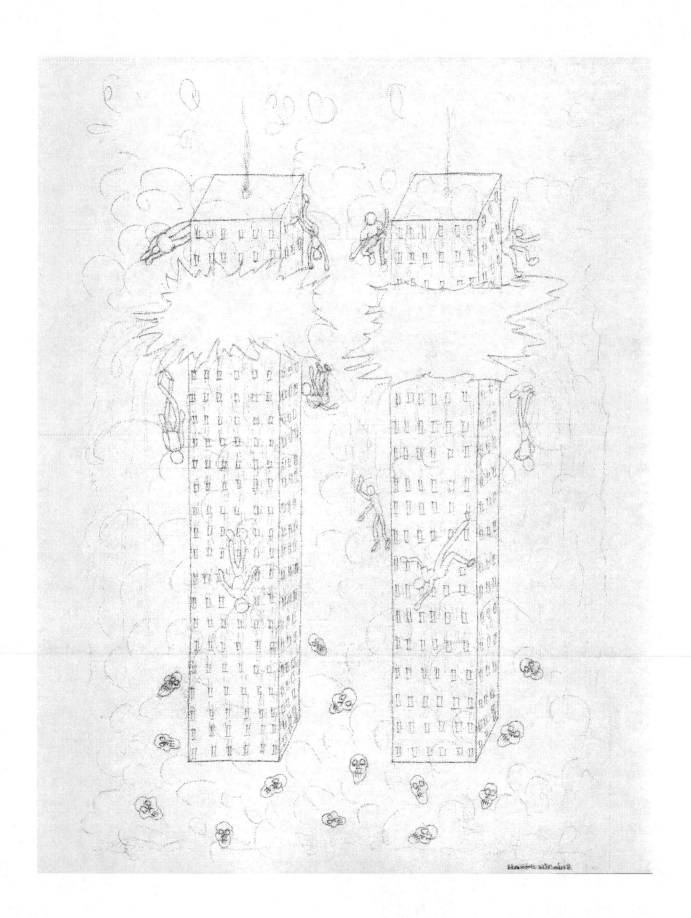

The Invisible Hand

In this exhibit, I demonstrate my passion and love for God. No matter where you are, you are in the hand of the Lord.

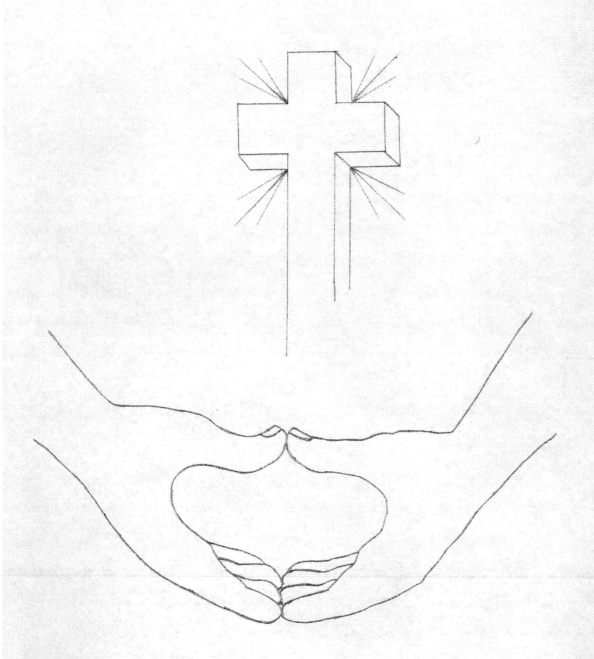

Harry Nicolas

We Are One

This portrait is a celebration of love. Around the world, we try to abide by one word: love. It's a wonderful thing. This piece is a revelation of the human anatomy. The message here is that with a brain you can do anything, even fall in love.

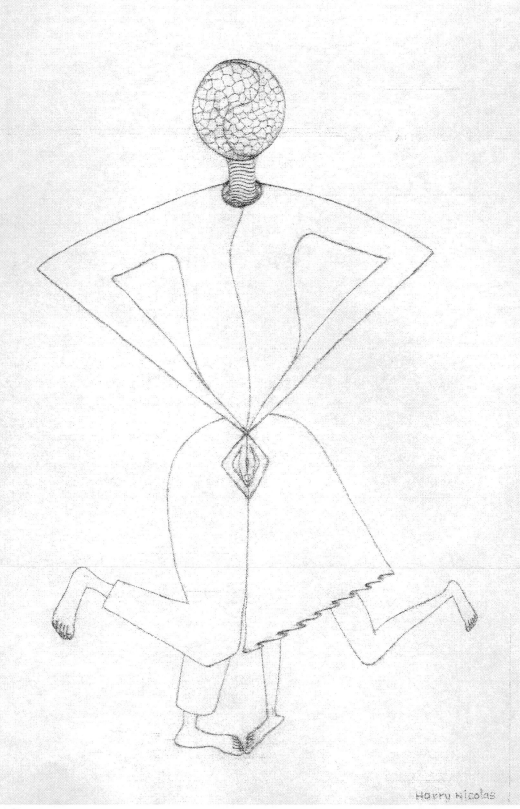

Harry Nicolas

Children of the New Millennium

This is a tribute to children around the world. These children have different ethnic and socioeconomic backgrounds and genetic make-ups. With reaching hands they can communicate with each other. As a sign of love, I wish to have them all.

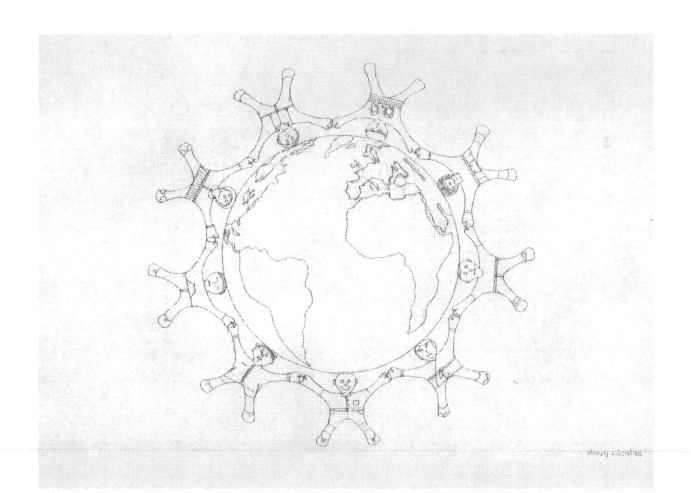

Harry nicolas

The Fine-Arts-Gifted Children

Once again, the children gifted in the fine arts are playing a beautiful masterpiece, "The Sound of Music."

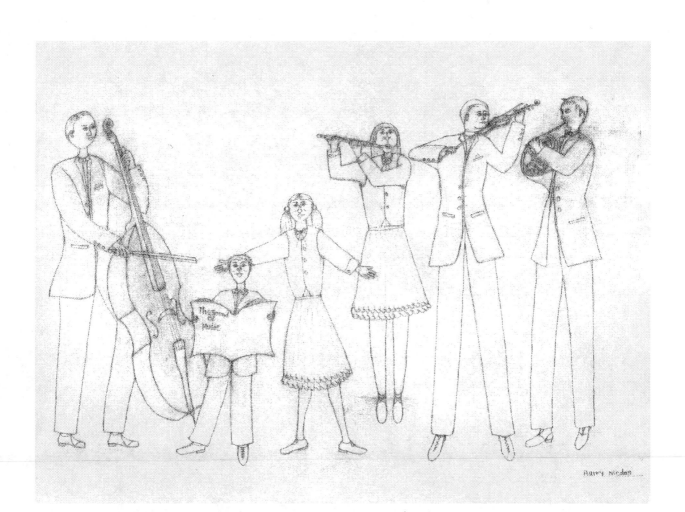

A Mother's Love

This scene represents a mother's true love for her hungry baby boy. Without hesitation, she exposes herself to breastfeed the little one. There's nothing better than Mom's milk. Join my exploration of where we all come from.

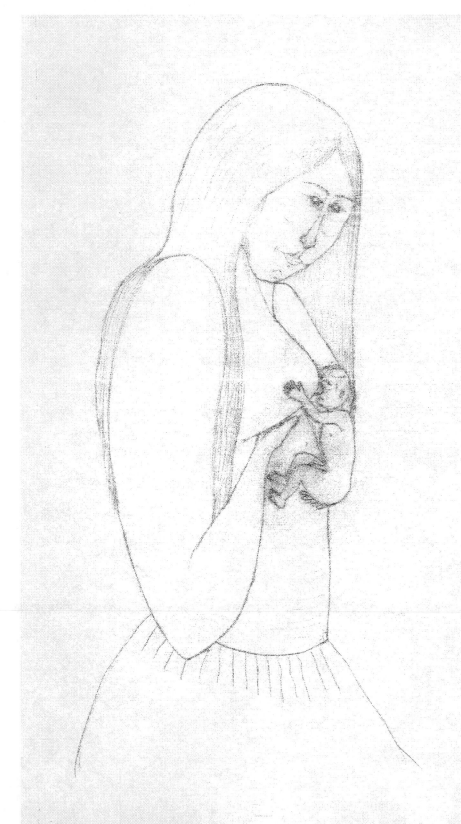

Harry Nicolas

Eclipse of the Sun

A sunbeam is being cast by a stubborn cloud after a tropical rain. It's a magnificent view, especially if you experience it in the Caribbean—watching the droplets falling from the leaves into the stream, set to the melody of a chirping bird.

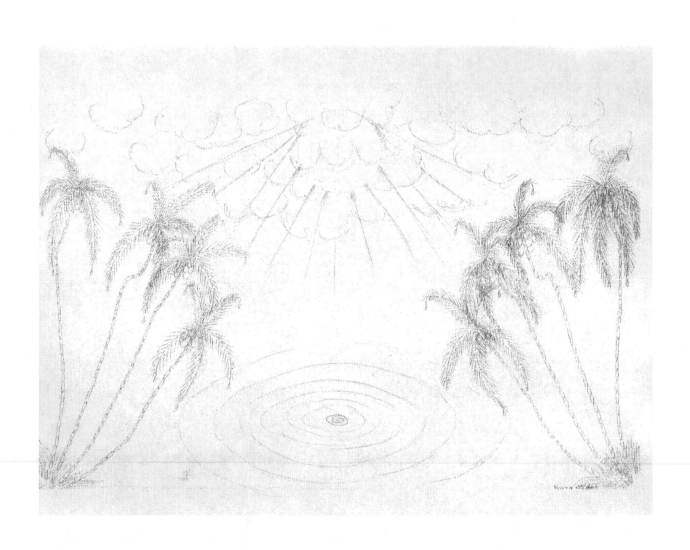

Good Old Santa

This is amazing: Santa, on Christmas Eve, goes out of his way under a bright full moon to save Christmas and to celebrate the birth of Jesus Christ. While the hot air balloon rises up toward the sky, he plans to drag the gift basket's center of gravity to the children below—so they can rejoice under a display of Christmas spirit. You can just hear the echo of the jingles rising from the earth.

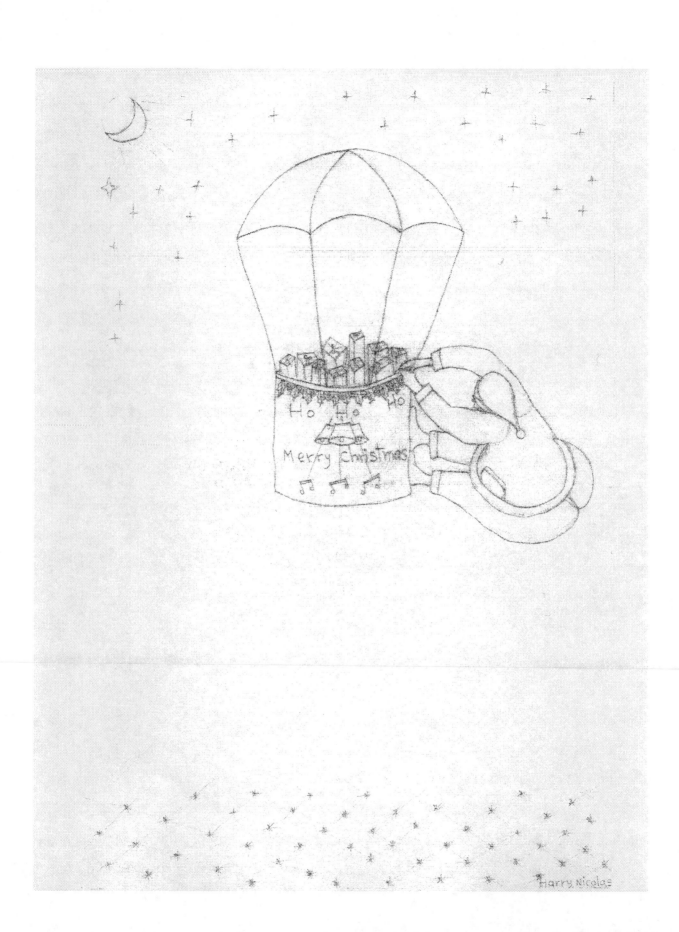

The Maestro Plays

This portrait is dedicated to the fine arts. The conductor is rehearsing Pachelbel's *Canon in D* with the group.

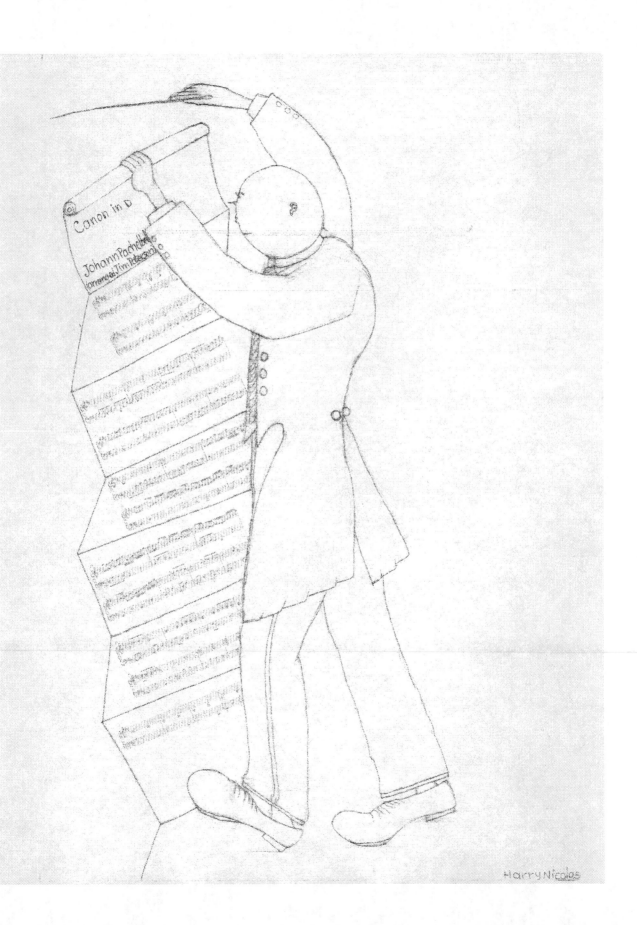

Soccer Explosion

Under a picture-perfect sky the tension was very high. At the last second of the game, a bicycle kick in the penalty area surprised and buried the pumpkin-head goalie. *Gooooaaal!*

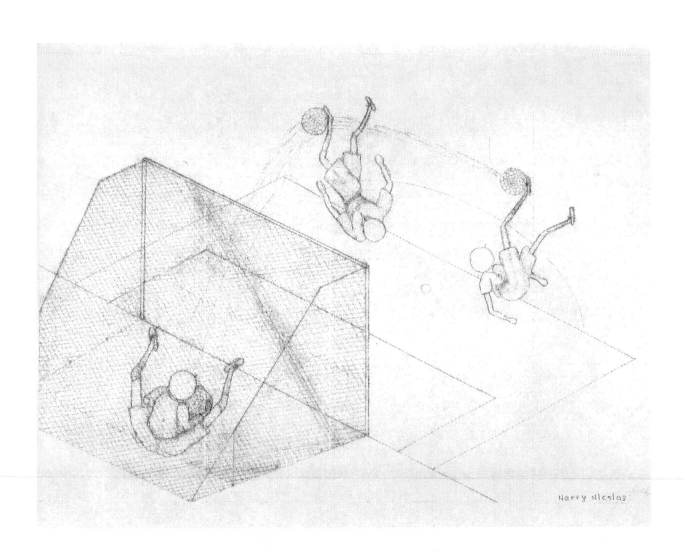

Harry Nicolas

The Human Bridge

Two athletic body builders offer their services to a stubborn but charming spoiled brat who wishes to cross the stream just for fun.

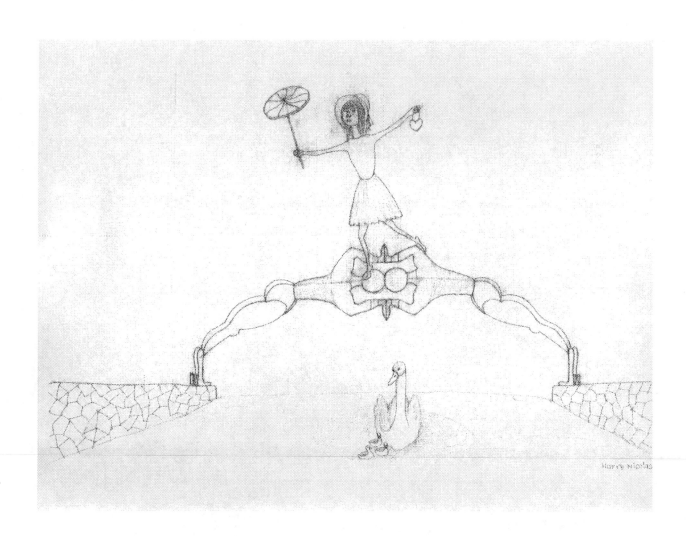

A Woman Valentine

This portrait shows the glamour and beauty of a remarkable woman.

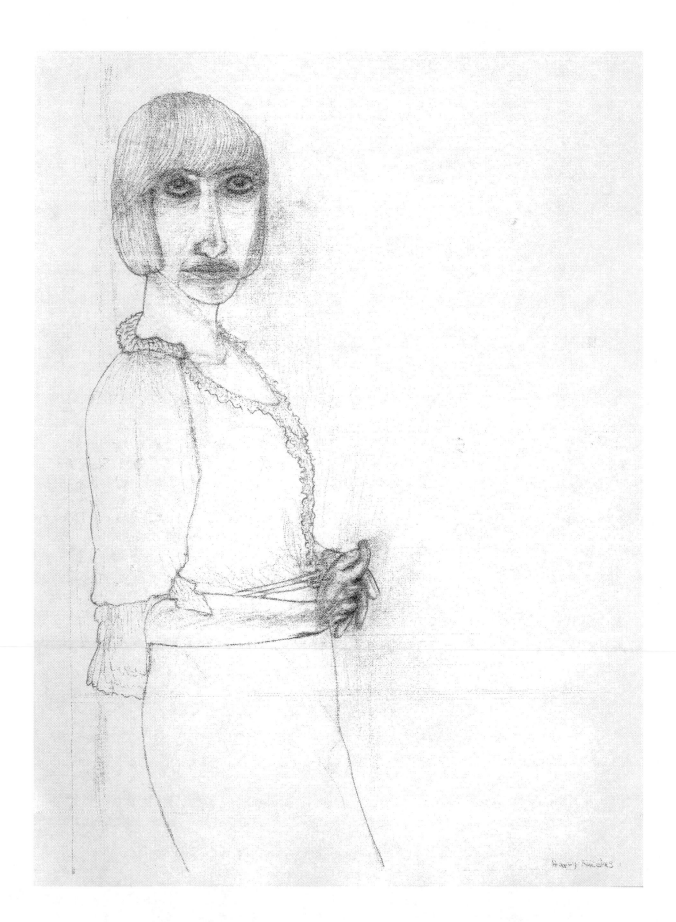

Perilous Moments

In this tragic scene, a boat has sunk on a stormy night. Only the captain has survived and is now fighting for his life. Will he have a chance? Only God knows his fate. Fleeing Cap Haitian after the recent coup d'etat, he was one of the thousands attempting to escape that didn't make it. All the turmoil encountered on the sea causes the boat to sink without a trace. All that's left are the parcels containing their belongings. Once again, even superstitiously asking for safe passage from the God of water does no good. They weren't that lucky.

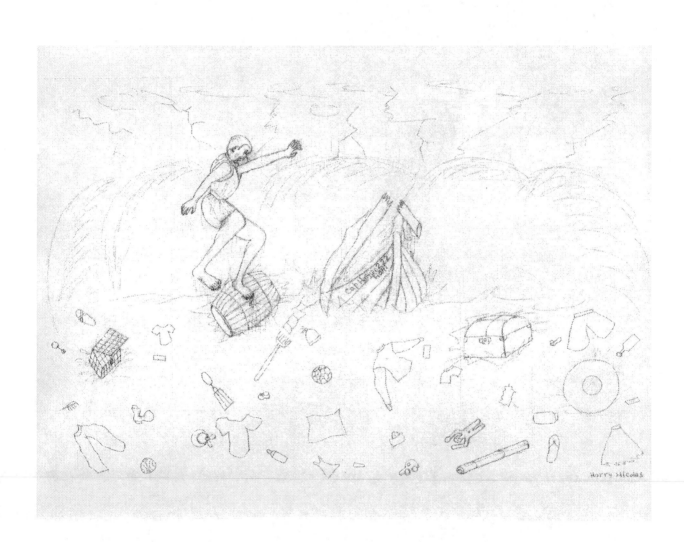

Recess

There is no better joy for children than when that time comes during a school day for recess. You can see the glimmer in their eyes as they finally get to play with their peers.

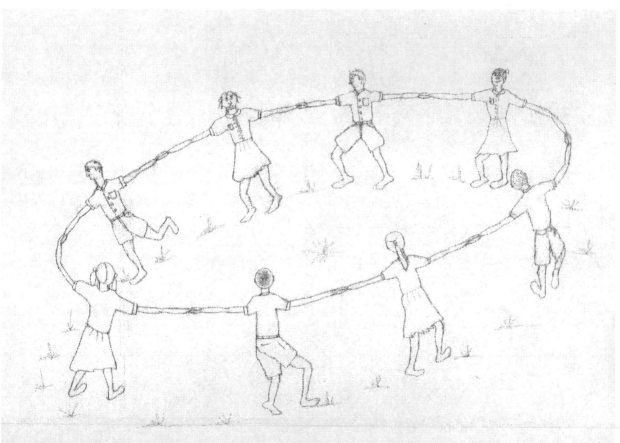

Ballerina

She is graceful while warming up and preparing for her classical steps on point, but first the muscles need to be ready. She is preparing for some fancy footsteps, which will bring joy to the rest of the world.

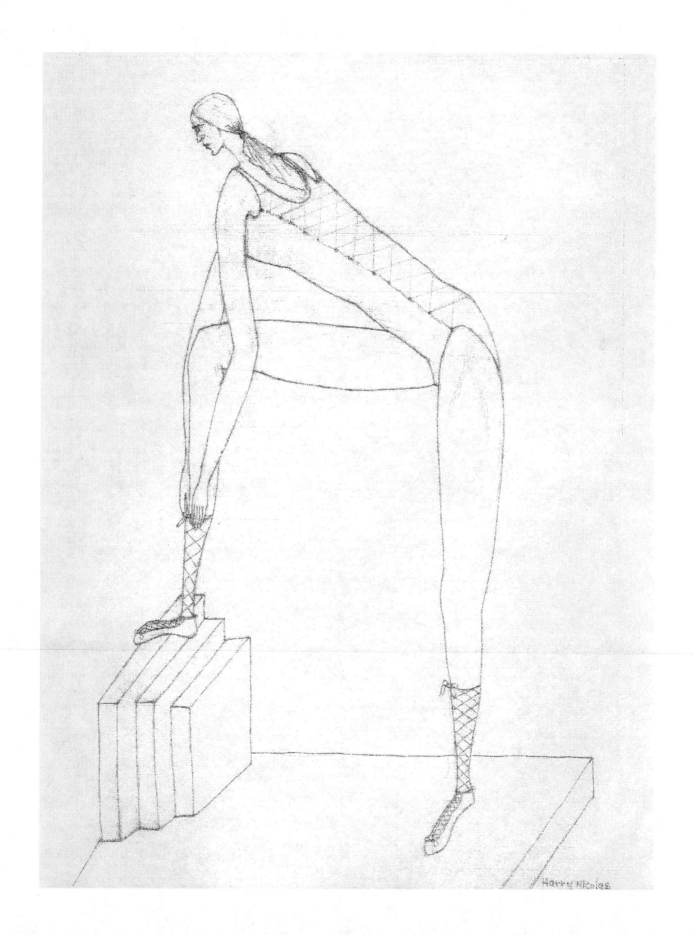

Harry Nicolas

The ICU Code

This portrait represents the most poignant moment for me: it's a true story, illustrated in a detailed sketch. This is a human stampede in a hospital. You can feel the beat of their feet like a drum. The entire medical staff rushed to the ICU unit to save my baby's life—she needed resuscitation and was struggling for every breath. Praise the Lord—she made it.

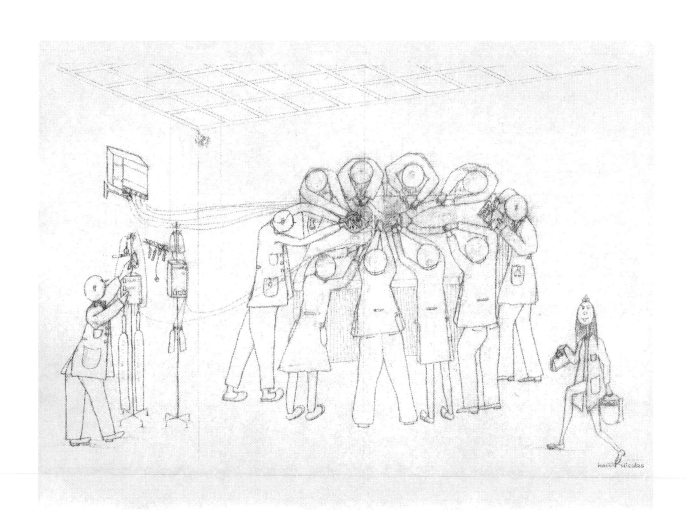

The Chair

Have you ever seen a physically challenged person in a wheelchair lose a wheel from the wheelchair? A screw loosened, the wheel flew off, and the patient tipped over and ended up on the ground. *Ouch*! Horrible and very graphic isn't it? It looks like a disaster you watch on TV, but it happens in real life. Few people know how much it takes to care for a loved one with special needs. It takes the whole world to keep up.

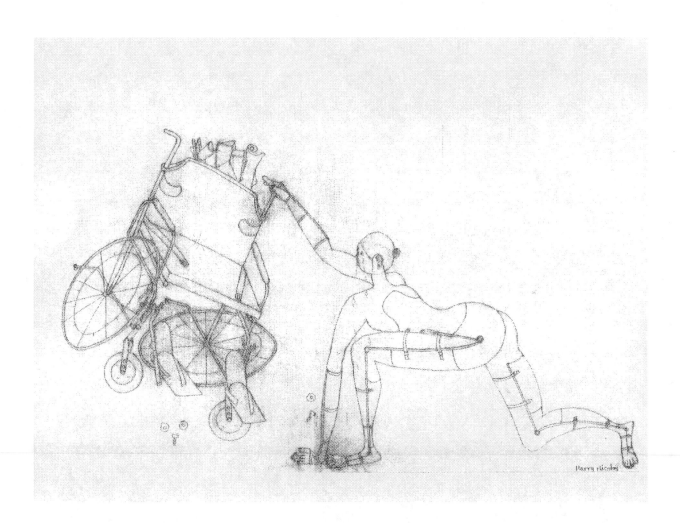

Labor

God is amazing in using a woman as a life-giving instrument, placing a baby in her womb for nine months. There is formation, then transformation when at last the infant emerges after a full-term pregnancy. It's the greatest joy for a mom who desperately wants to see what the baby looks like after all this time. In this emotional moment I expose the real thing: a mother delivering a baby normally, while screaming at the top of her lungs.

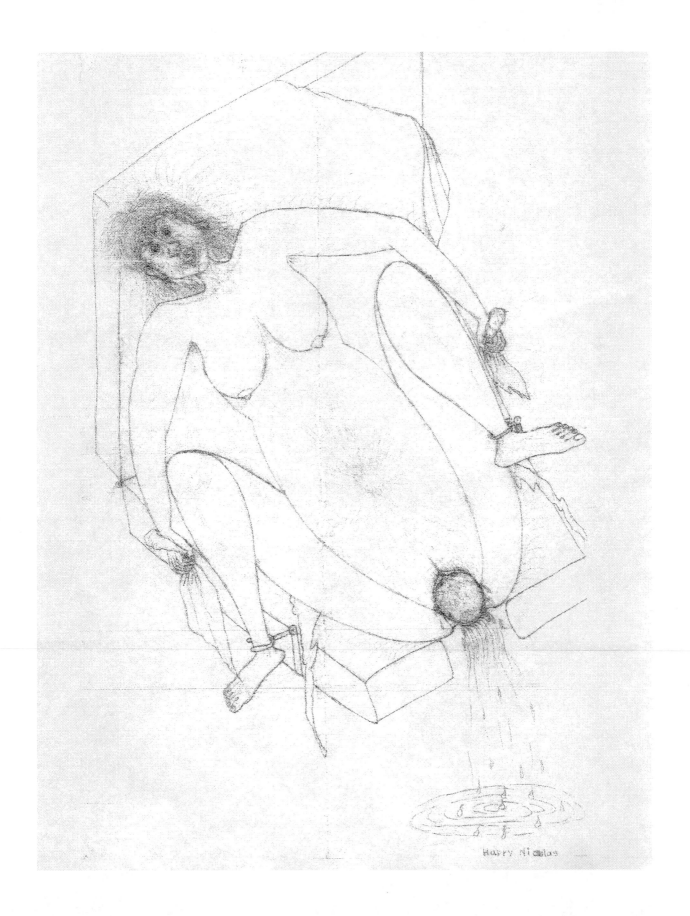

Harry Nicolas

The Robbery at the Nicolas Apartment

The robber depicted here was caught after fleeing through the bathroom window hanging onto the fire escape held by his two ankles. He pleads for his life with a tense exchange of words.

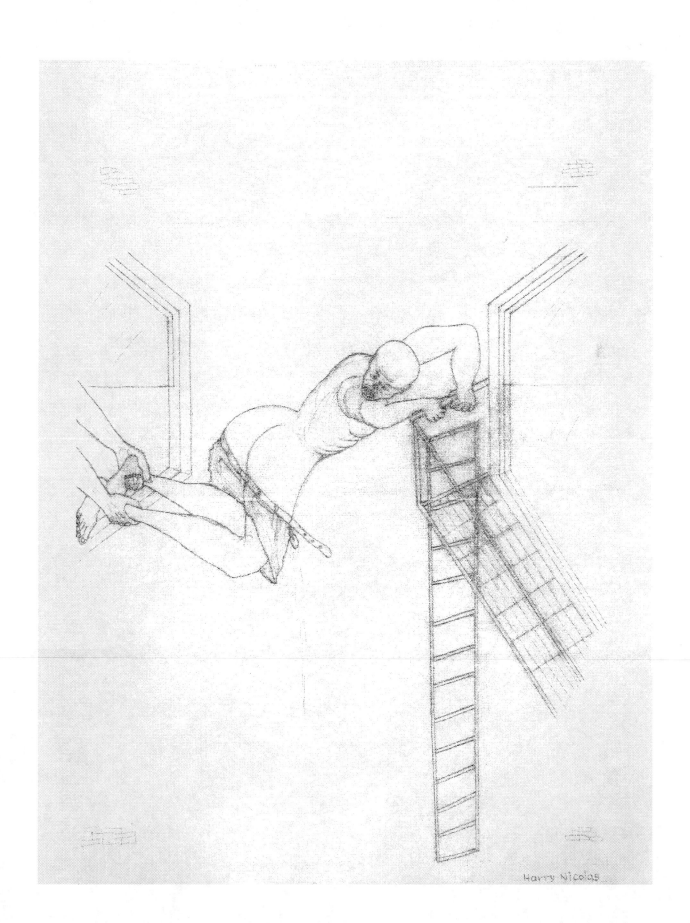

Harry Nicolas

Peace and Love

We are all humans who make mistakes. This piece shows that with peace and love and a pat in the back, we can dispel our differences and set out all over again.

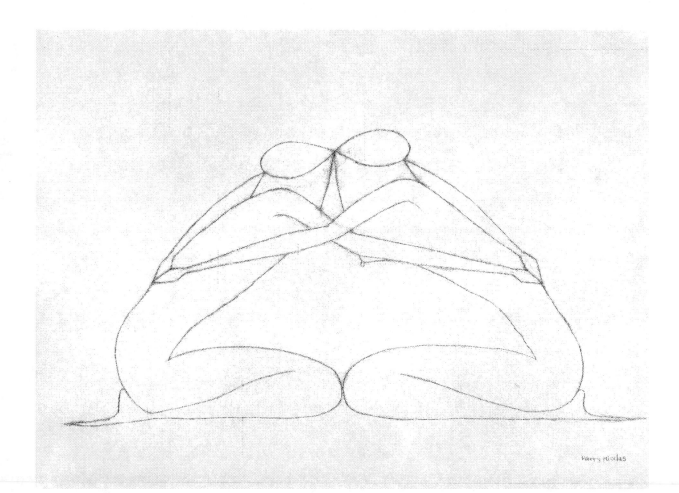

God Bless the Children

We must praise the Lord for allowing the birth of a child. Only He could make it happen.

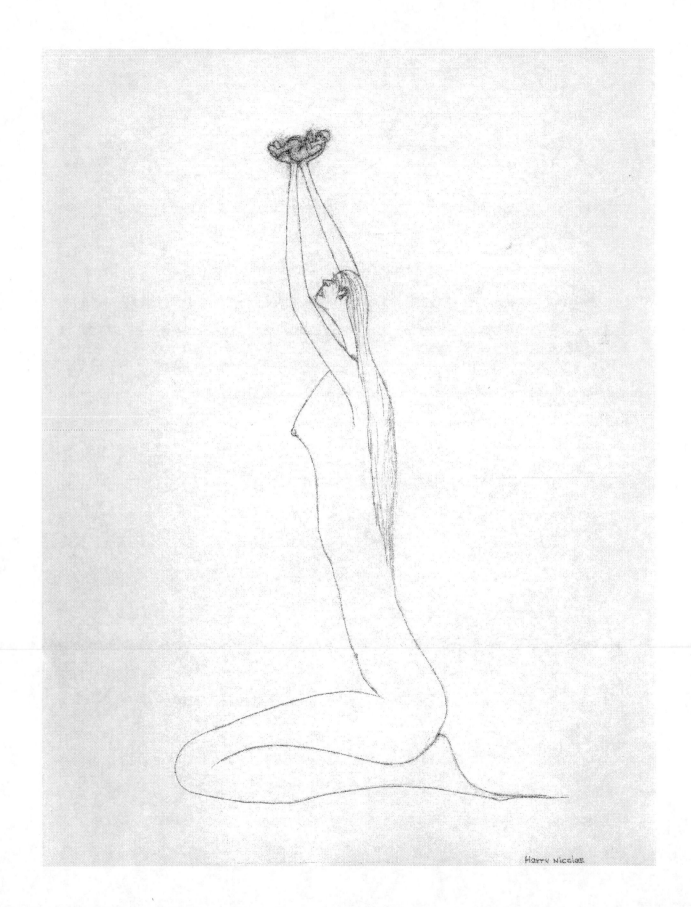

Harry Nicolas

The Artist's Final Touch

Every millennium, an artist reveals his love for a woman. In this picture the artist is being seduced by the charms of a woman. She's relaxed in her yoga position, letting herself go, as mind, body, and soul drift far away.

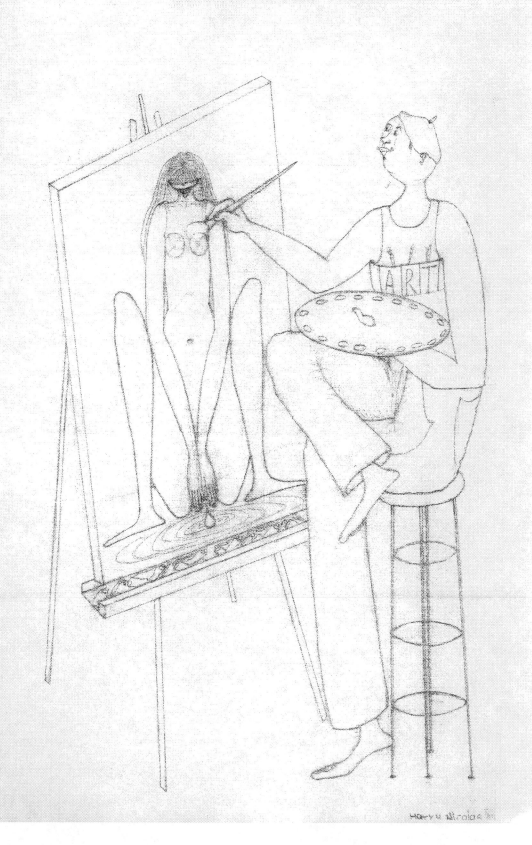

Conclusion

I hope reading this book has been a long and rewarding journey. These sketches are intimate and personal, especially the last one. I hope you enjoyed trying to understand my artistic philosophy. Keep reading, and I hope you look forward to my next book. Good-bye for now.

978-0-595-44113-6
0-595-44113-0